GRIZZLY GIANT

YOSEMITE ICON

YOSEMITE CONSERVANCY

YOSEMITE NATIONAL PARK

You're here to read about the Grizzly Giant, one of the world's biggest and best-known trees. Remarkable for so much, including a distinct tilt, the Grizzly is about 20 feet (6 m) taller than another famous leaning giant, Italy's Tower of Pisa.

First, let's meet the tree's home: Yosemite National Park, which encompasses 1,187 square miles (3,074 km2) of California's Sierra Nevada range.

Within that vast area, you can hike Yosemite's more than 750 miles of trails, picnic on riverbanks, wade in mountain lakes, and watch sunsets from overlooks. And you'll spend a lot of time gazing up at the park's high cliffs, waterfalls, and peaks.

In many parts of Yosemite, you'll be surrounded by shiny granite—remnants of magma that solidified deep underground 100 million years ago. Over eons, water has sculpted the landscape. Rivers carved canyons and valleys, and slow-moving glaciers polished domes and left shallow ponds, leaping waterfalls, and debris piles (*moraines*) in their wake.

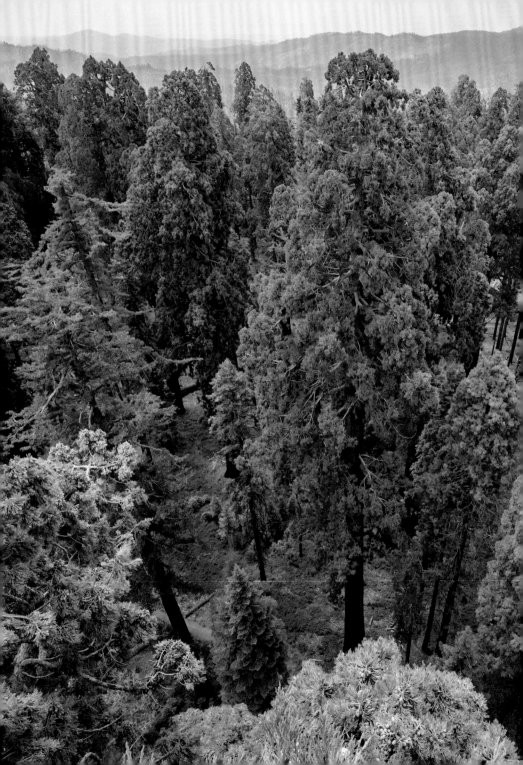

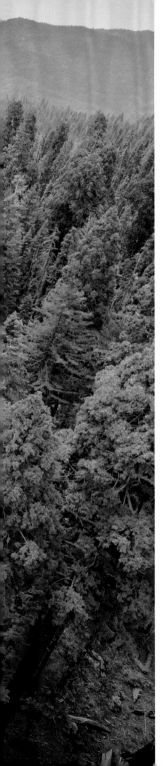

Thanks to its vast elevation range—from 1,800 feet (549 m) to over 13,000 feet (3962 m)—and varied habitats, including alpine meadows, rocky plateaus, and old-growth forests, Yosemite supports a lot of life. Great gray owls nest in broken-topped trees, red-legged frogs splash in wetlands, bats roost in cliff crevices, and pikas chirp from high-elevation boulder fields.

The park is also an oasis for more than 1,400 plant species, including milkweed, where monarch butterflies lay eggs; California black oaks, whose acorns have long nourished life in the region; and rare flowers that bloom only after wildfires.

Among Yosemite's plants, nothing attracts as much attention as giant sequoias. These titanic trees are found only in the western Sierra and can live for more than three thousand years.

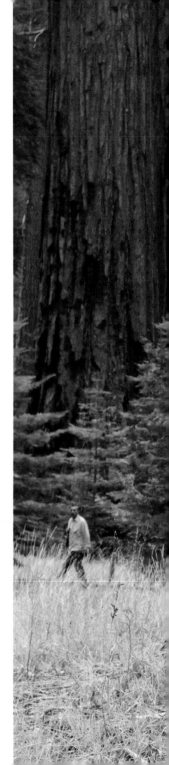

Since well before the park's oldest living sequoias took root, Yosemite has been the ancestral home of the people now known as the Bishop Paiute Tribe, Bridgeport Indian Colony, Mono Lake Kootzaduka'a Tribe, North Fork Rancheria of Mono Indians of California, Picayune Rancheria of Chukchansi Indians, Southern Sierra Miwuk Nation, and Tuolumne Band of Me-Wuk Indians. When exploring Yosemite, please remember that this place is still home to the Traditionally Associated Tribes, who retain deep cultural, spiritual, and ecological ties to the land and who ask that this sacred place be treated with the utmost care and respect.

In this big, ancient, picturesque place, you'll sense the weight of history and wonder at natural processes. And you may feel really, really small. That feeling is especially visceral among the sequoias.

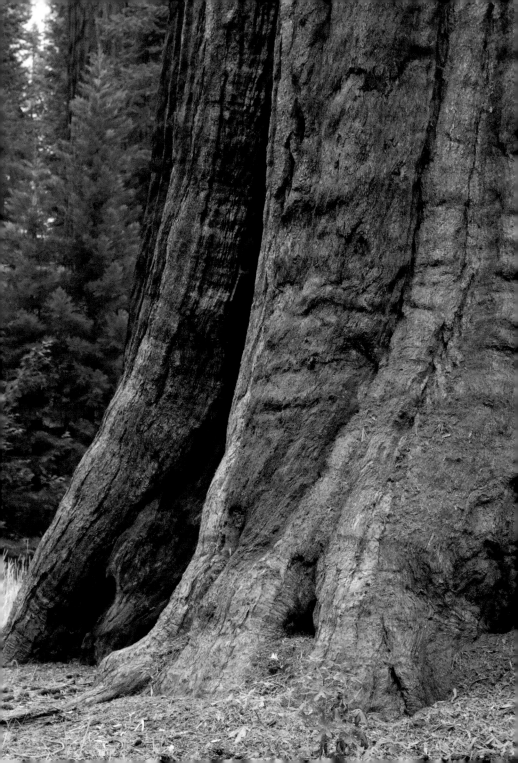

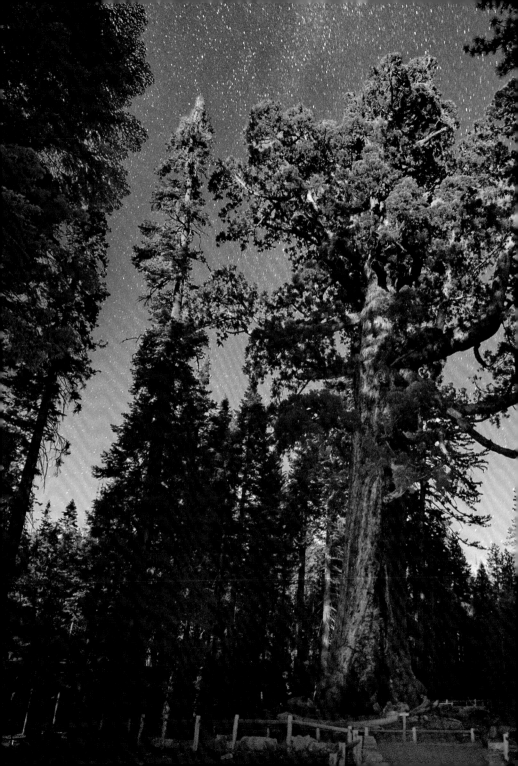

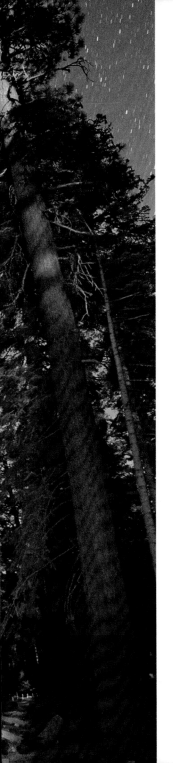

We count the Grizzly Giant among the park's icons, the features that epitomize Yosemite's beauty and history. But unlike other iconic features (think Half Dome and El Capitan), the Grizzly Giant is alive—and has been for thousands of years. How did it get here, and what does its future hold? Let's find out.

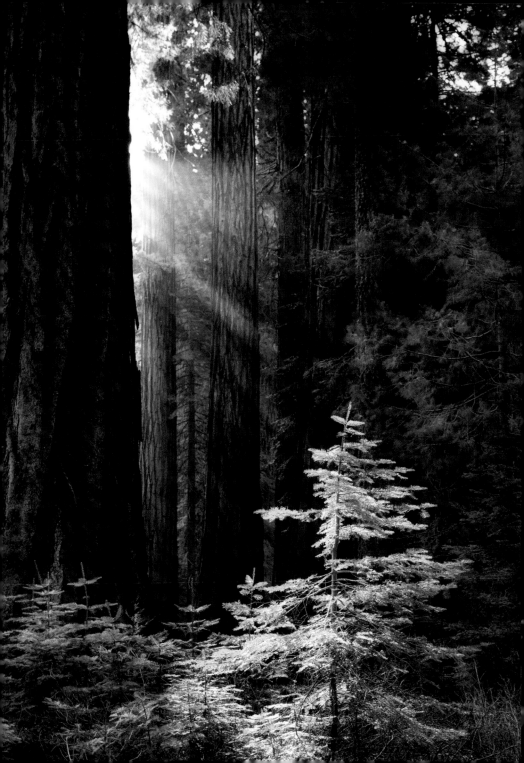

Natural History

Giant sequoias *(Sequoiadendron giganteum)* are part of a group of conifers commonly called redwoods, for their russet trunks. Along with giant sequoias, which are native to California's Sierra Nevada range, the redwood group includes just two other living species: the pyramid-shaped, relatively petite dawn redwood from China, which drops its leaves seasonally; and the coast redwood, the world's tallest tree, which is native to the U.S. West Coast.

G iant sequoias are among Earth's largest living things. A mature sequoia can be more than 30 feet (9 m) wide and 300 feet (91 m) tall, and it can weigh more than a pair of blue whales, 90 African elephants, or 8,500 adult humans. And healthy sequoias keep growing. Larger, older sequoias tend to gain more wood each year than smaller trees do because they have more leaves, which means a greater capacity to photosynthesize.

On lists of the world's largest living sequoias, the Grizzly Giant, in Yosemite's Mariposa Grove, currently ranks twenty-fifth or twenty-sixth. It's *very* big.

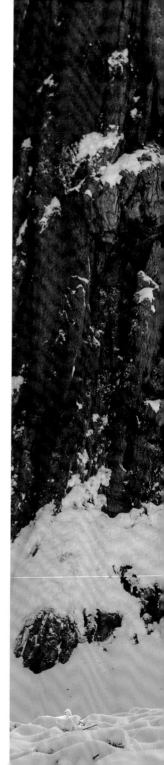

THE BACKSTORY

F ossils tell us sequoias were growing on Earth 150 million years ago, well before Yosemite's granite started cooling underground. Their range has varied, but today sequoias grow naturally only within a 3,750-square-mile (9,712 km²) zone on the Sierra Nevada's western slopes, including in Yosemite.

Why here? Moisture, mostly. In much of this sequoia-friendly zone, deep mineral soils soak up rain and snowmelt to provide year-round water for the thirsty trees. Sequoias use extensive root systems to drink as much as 530 gallons (2,000 L) per day. Scientists have found that sequoias in particularly damp areas, like Mariposa Grove, have shallow roots that extend out

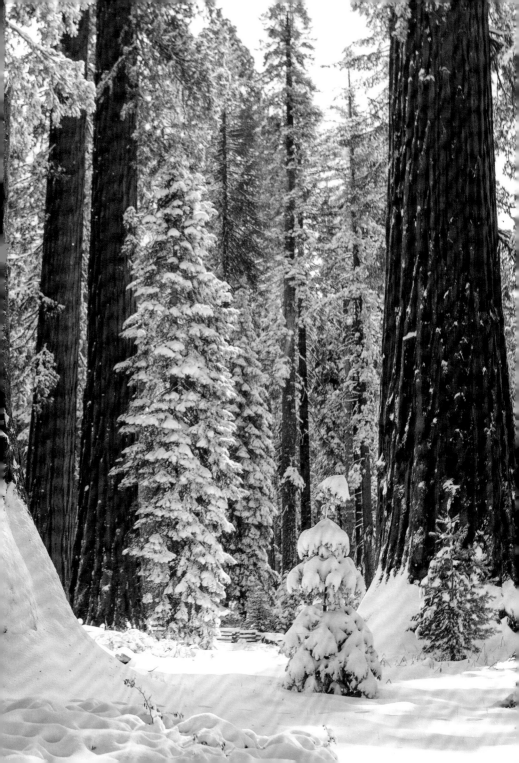

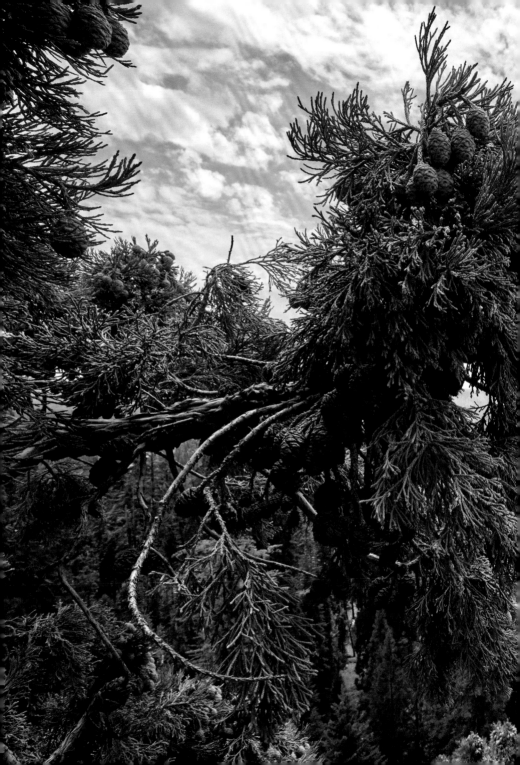

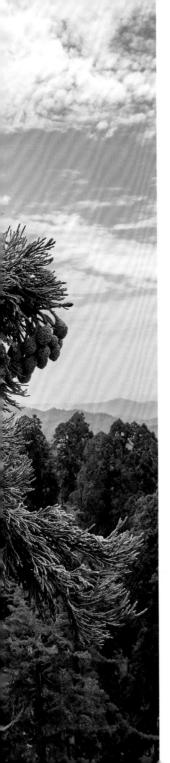

far from their trunks. The trees are most commonly found at middle elevations, usually between 4,600 and 7,000 feet (1,400 to 2,100 m), although their full known natural range extends from just below 3,000 feet (900 m) to nearly 9,000 feet (2,700 m).

Once they're a century or two old, sequoias start producing thousands of cones. The cones, similar in size and shape to chicken eggs, are packed with as many as two hundred seeds apiece. Each seed is a tiny disk, about as big as an oat flake. A cone may stay sealed for years before releasing its seeds, a process sometimes helped along by Douglas squirrels and long-horned beetles chewing through the cone's scaly walls. Low-intensity fires can also set seeds free by drying the cones.

Once released, sequoia seeds face a challenging journey. Most don't survive. Around three millennia ago, one sequoia seed in western North America got lucky. It landed on a patch of exposed, moist soil, sprouted, and grew roots. As the new tree raced to the sunlight, it grew thick, spongey, ribbed red-brown bark, a barrier against wildfires, and produced bitter tannins to ward off insects. Over centuries, the tree stretched taller and taller, endured droughts and blizzards, and broadened its cinnamon-hued trunk. Eventually, its lower limbs died and dropped off, an evolutionary feature that provides a measure of safety in a fire.

That tree is the Grizzly Giant.

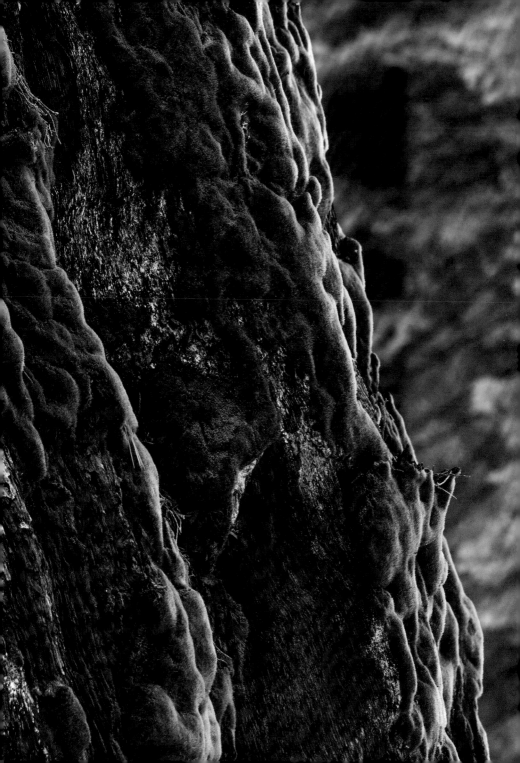

The same tannic acid that protects live sequoias from insects also keeps the trees from decaying quickly after they're dead. The Fallen Monarch still looks much like it did one hundred years ago.

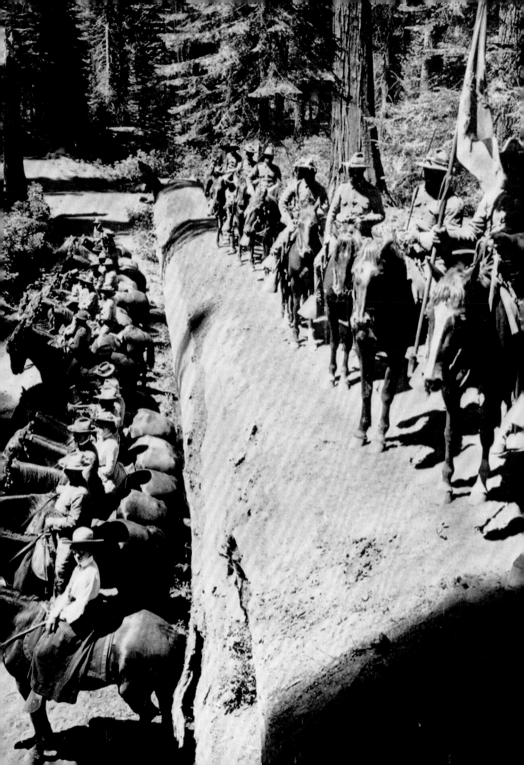

THE BASICS

The Grizzly is old, even by sequoia standards. Scientists estimate the Grizzly has been growing for about 3,000 years. (The oldest known sequoia, a now-dead tree in Sequoia National Forest, lived for an estimated 3,200 years.)

The Grizzly now measures 208 feet (63.5 m) tall. It weighs an estimated 2 million pounds (907,000 kg) and its trunk, at breast height, has a 71-foot (22 m) circumference; it would take thirteen adults holding hands with arms outstretched to encircle the trunk.

Besides being gargantuan, the Grizzly stands out because it's noticeably off-kilter, leaning south. Some of its branches jut out horizontally and then angle up, like arms bent at the elbow, a feature you may notice on other old sequoias. One limb about halfway up the trunk is more than 6 feet (2 m) in diameter, broader than many people are tall. Like all sequoias, the Grizzly has striated red-brown bark and prickly, scaly green needles.

Sequoias are notably sturdy—they are relatively fire- and insect-resistant, thanks to thick, fibrous, tannin-rich bark—but decades of harsh conditions can leave a mark. At the Grizzly's base, you'll see a triangle of scorched wood. If you stand back and look up, you might spot scraggly dead branches at the top of the tree. Such trunk scars and "snag tops" are hallmarks of old sequoias that have withstood centuries of droughts, lightning strikes, and fires.

Photosynthesis, which is needed for the growth of leaves, roots, wood, and bark, will occur when sunlight strikes a hydrated leaf. Giant sequoias, along with coast redwoods, have more leaves than any other tree species. These trees can have growth rates of up to 1500 pounds (700 kg) *per year,* which is by far the fastest growth among all tree species. On pages 24 and 25, a photographic comparison from 1861 and 2016 shows the Grizzly Giant, its crown leafier and its trunk noticeably thicker in the recent photo. Carleton Watkins's photo is among the first ever taken of a giant sequoia.

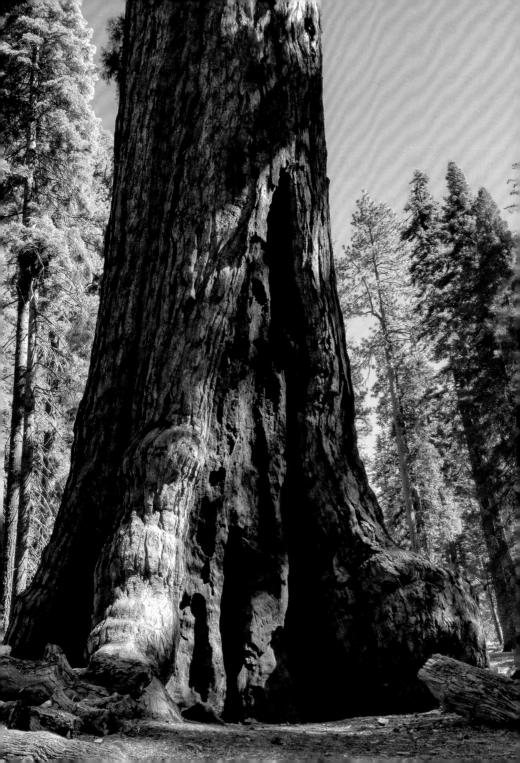

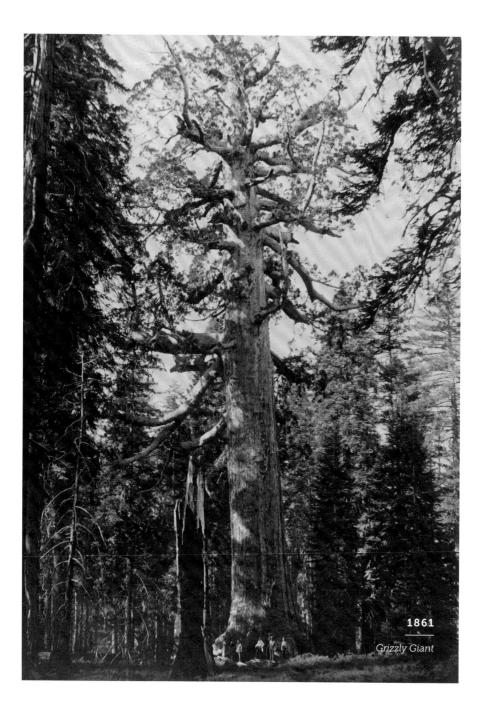

1861

Grizzly Giant

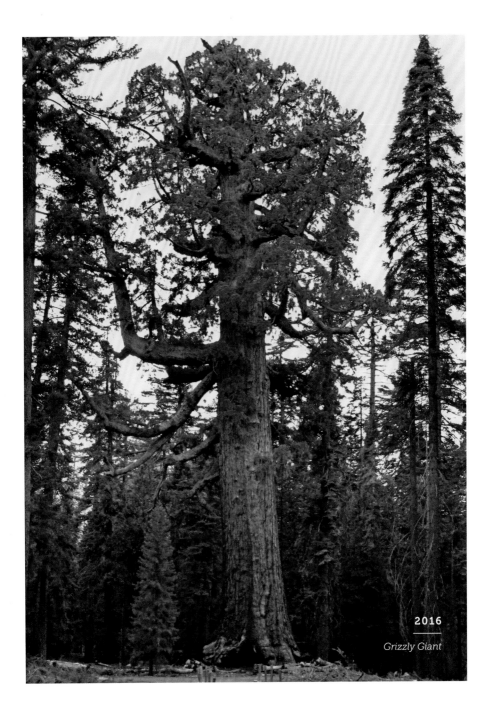

2016

Grizzly Giant

THE ECOSYSTEM

Today's giant sequoias live together in groves that are relics of larger, long-gone forests. The exact number of remaining groves depends on whom you ask, but there are at least sixty-five, three of which are in Yosemite. Tuolumne Grove, off Tioga Road, and Merced Grove, off Big Oak Flat Road, are both near Crane Flat; and Mariposa Grove, near Wawona, is home to about 500 of the park's approximately 550 mature sequoias.

The Grizzly Giant is one of Mariposa Grove's largest trees, but there are plenty of other impressive sequoias nearby. The Telescope Tree has been hollowed out by fire but it still stands upright. The Columbia Tree, reaching up 280 feet (85.3 m), is Yosemite's tallest tree.

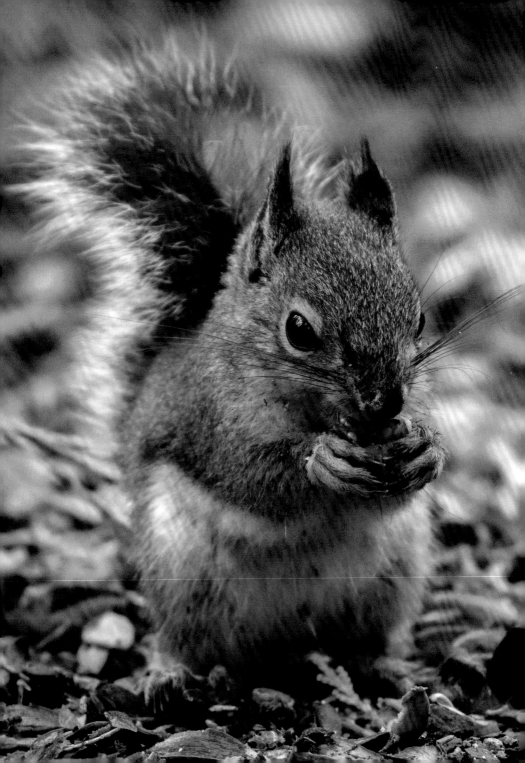

Sequoia groves support plenty of other life, too. More than 70 vertebrate species and at least 140 kinds of insects make their homes in Mariposa Grove. Douglas squirrels, often called chickarees, feast on sequoia cones. Pacific fishers and California spotted owls live in tree cavities. Multiple bat species, including western mastiff and western red bats, roost and feed among the sequoias.

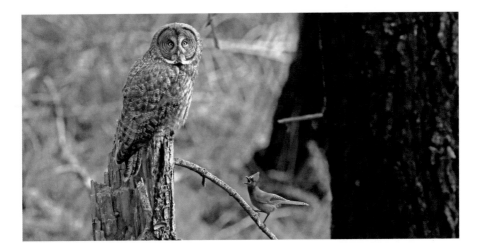

Look for nuthatches and brown creepers gleaning bugs from bark, and for Steller's jays and great gray owls sharing space. Listen for pileated woodpeckers drumming square holes and for golden-crowned kinglets singing reedy soprano melodies from high perches. On the forest floor, you might spy a northern alligator lizard—or just its wriggling tail, detached and left behind as the rest of the reptile's body scoots to safety. Small salamanders, including orange-spotted Sierra Nevada ensatinas, hide in damp spots under logs and leaves.

Among the non-sequoia plants that live in Mariposa Grove are evergreens such as incense cedars, white firs, Douglas firs, and sugar pines. Sugar pines can rival sequoias in height, while Douglas firs can be as tall as coast redwoods (250 feet/76 m). Closer to the ground, look for shrubby greenleaf manzanita and mountain whitethorn, and for striped stalks of horsetail, a primeval fern relative. You may find rarer plants, too, like Coleman's piperia, a translucent green orchid, and Lemmon's wild ginger, which has heart-shaped leaves.

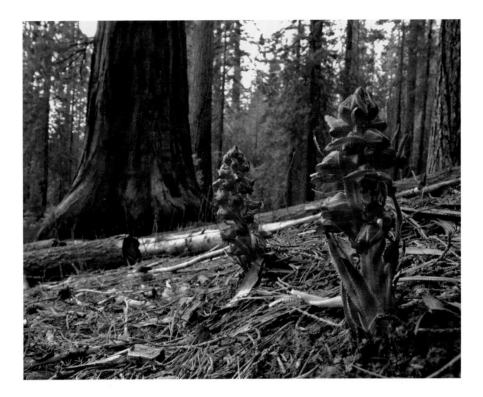

Snow plants, the grove's most vibrant botanical residents, unfurl bell-shaped red blooms in spring, but their most intriguing feature is below ground. Instead of using sunlight to survive, snow plants tap into the mycorrhizal fungi attached to conifer roots, plundering the fungal network that helps nourish and protect the trees.

For thousands of years, the Grizzly Giant has been an integral part of this ecosystem. And when it falls, ten or one hundred or one thousand years from now, this iconic tree will continue to play an important role, feeding bacteria and fungi as it slowly decomposes—and maybe even becoming a "nurse log," with seedlings rooted in its trunk.

The Washington Tree, a 36,800-cubic-foot (1,043 m³) behemoth, is one of the park's largest trees by volume. It's huge enough to host another tree.
A slender, nearly 18-foot-tall (5.4 m), century-old ponderosa pine rooted in a long-decayed portion of this giant's trunk lives high above the ground as an epiphyte—a nonparasitic plant that grows on another organism or object.

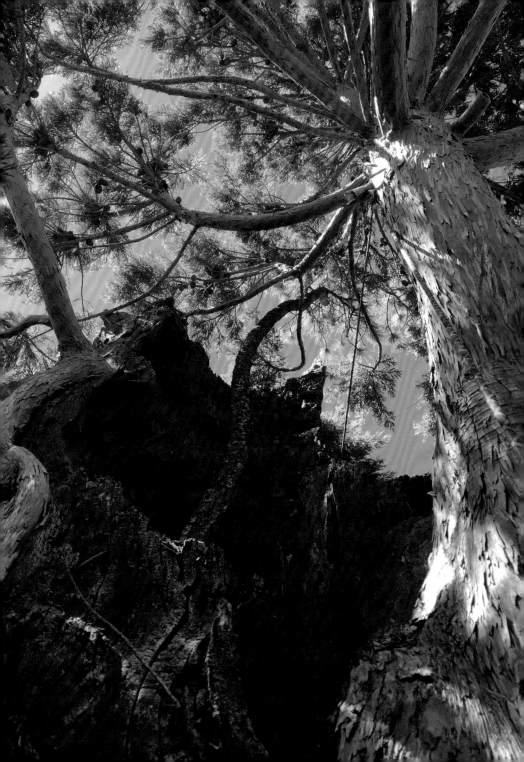

Human History

Four of the seven tribes native to Yosemite spoke related languages derived from the Numic language family found in the Sierra Nevada and areas to the east. Their name for the formidable giant sequoia and its relatives is Wowona. The historic hamlet of Wawona in the park owes its name to the trees in nearby Mariposa Grove. Over the last century and a half, dramatic shifts have transformed the grove—in good ways and bad— and made the Grizzly Giant world-famous.

TRADITIONAL STEWARDSHIP

The ancestors of the Traditionally Associated Tribes stewarded the land now called Yosemite, including its giant sequoias, for untold ages. They lived in and traveled throughout this region, setting up seasonal and year-round villages, climbing to high promontories to look for wildlife and storm clouds, hunting in forests and meadows, and using fire to keep ecosystems healthy.

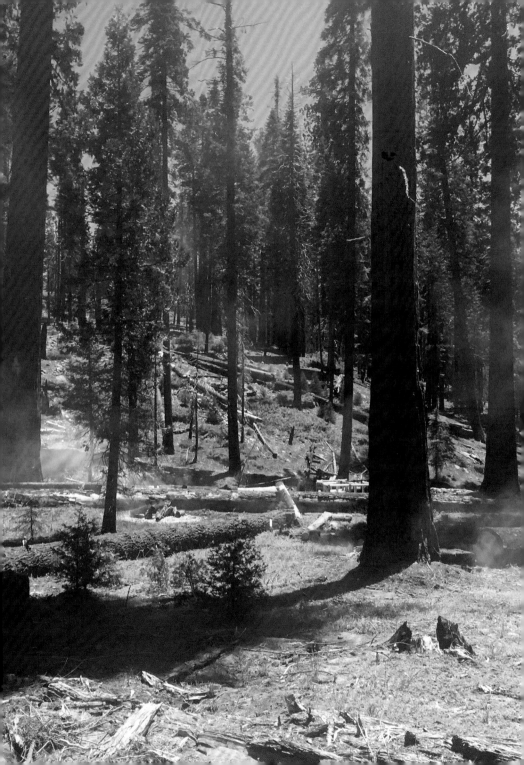

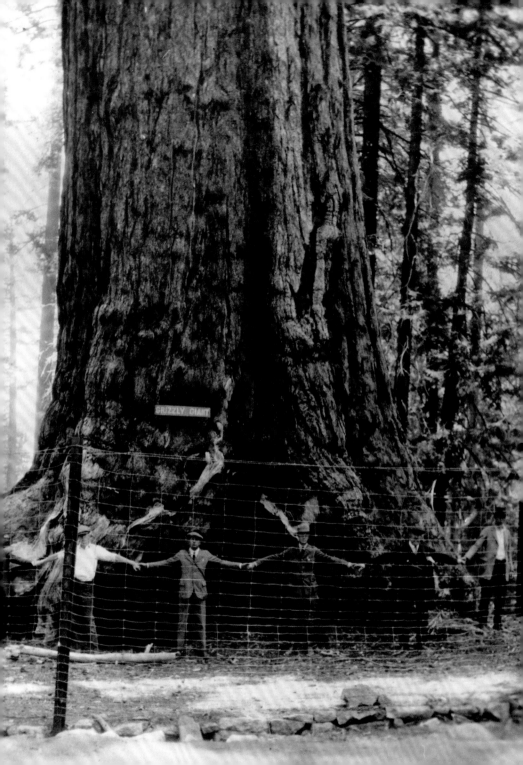

That way of life was violently disrupted in the mid-1800s, when outsiders seeking gold and land brought disease and discord to the region. In 1851, the state-sanctioned Mariposa Battalion marched into the Yosemite area, on a brutal mission to expunge the local population. After capturing villagers in an area not far from Mariposa Grove, the soldiers continued north to Yosemite Valley, roughly following the route of today's Wawona Road. They destroyed homes, killed or evicted residents, and forced survivors onto reservations.

In the years following the battalion's raids, Yosemite drew coast-to-coast attention. Paintings, sketches, and photographs—including, notably, the 1861 Carleton Watkins image of the Grizzly Giant on p. 24—helped publicize the Valley and the grove. The beauty of these places, and concern about sequoias being felled for timber, inspired the 1864 Yosemite Grant act, which placed Yosemite Valley and Mariposa Grove under California's control as the first protected public land in the United States, laying the groundwork for today's National Park System.

TUNNELED TREES AND CAVALRY

That legislation marked a new era for Mariposa Grove. Wawona resident Galen Clark, who had moved to the area in the 1850s and led tours of the grove, was appointed "guardian" of the newly state-managed lands. Clark, a keen student of the sequoias, built a cabin just uphill from the

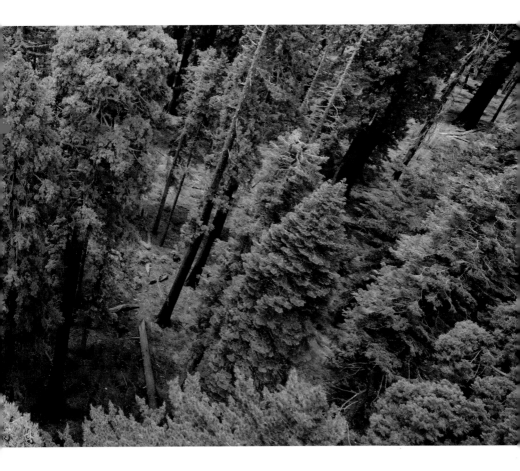

Grizzly Giant. Before long, others added trails, roads, and a hotel among the trees. In a move that is unthinkable today, the Yosemite Stage and Turnpike Company carved tunnels in two of the grove's sequoias so visitors could drive horse-drawn stages, and later automobiles, through the tremendous trunks.

Congress established Yosemite National Park in 1890, but the Valley and grove remained under state oversight. The National Park Service would not be founded until

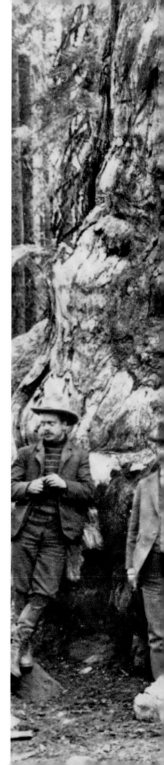

1916, so the U.S. Army patrolled the park. The troops, which included men from two of the army's four all-Black regiments, known as Buffalo Soldiers, set up a camp in Wawona, built trails, and patrolled the park. Photos from the late 1800s and early 1900s show mounted troops by the Grizzly Giant and on the Fallen Monarch, an enormous prone sequoia.

The Grizzly stars in yet another famous snapshot from that era: In 1903, President Theodore Roosevelt (center) posed with conservationist John Muir (with long beard) in front of the iconic tree while on a camping trip. During the excursion, which included a night beneath the Grizzly's high boughs, Muir argued that the Valley and grove should be placed under federal protection. His plea resonated, and in 1906, Roosevelt added both areas to Yosemite National Park.

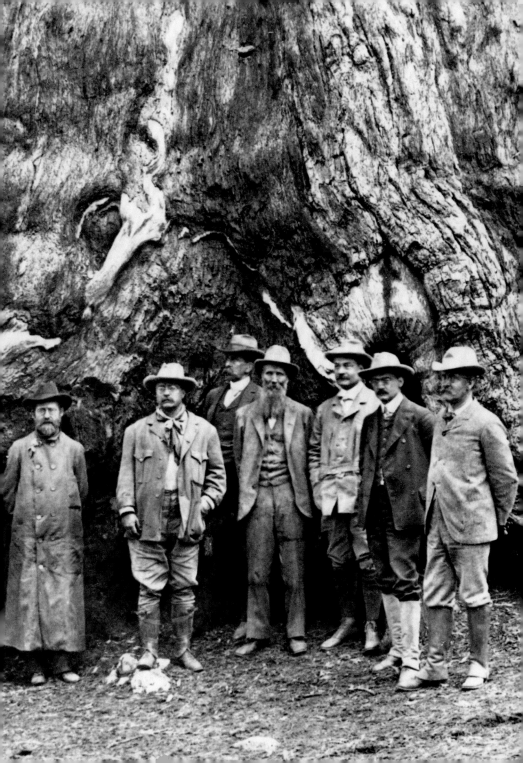

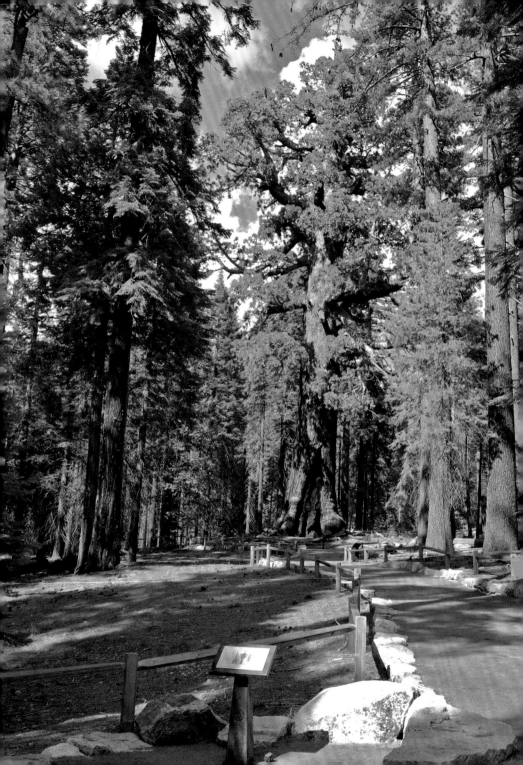

SAVING THE GROVE

In a shift away from millennia of natural and human-managed blazes that had helped sequoias grow and reproduce, park managers were now working to prevent wildfires from starting and spreading. The park service did return fire to the grove in the 1970s. However, new noises, like those from a generator humming among the trees, disrupted noise-sensitive wildlife such as pallid bats. Paved roads compressed roots and interrupted water flow.

After thousands of years of natural processes, development had visibly damaged the Grizzly Giant's home. In the early 2000s, the National Park Service embarked on a project to restore ecological health in Mariposa Grove and turned to Yosemite's Traditionally Associated Tribes for guidance.

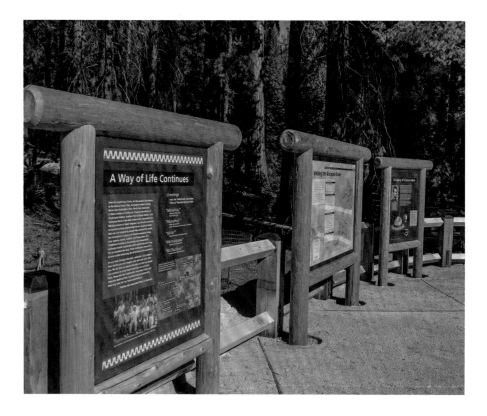

After the people native to Yosemite were violently forced out in the 1850s, some of their descendants returned soon after, often working for private employers and, later, also the National Park Service as a way of staying in their ancestral home. Today, Yosemite's Traditionally Associated Tribes regularly hold events in Yosemite and use traditional ecological and cultural knowledge to consult on park-related matters, including Mariposa Grove rehabilitation, a years-long effort that wrapped up in 2018. For more on tribal history, practices, and ongoing stewardship in the Yosemite area, read *Voices of the People* (see Resources, starting on p. 70).

When you visit the grove today, you'll find boardwalks over sensitive wetlands, native plants flourishing in the footprint of a former parking lot, and educational signs highlighting scientific research and traditional stories. At the Grizzly Giant, an accessible trail leads toward the impossibly wide trunk, but the tree is fenced off for its protection. You can't give it a hug, but you can gaze up in wonder from a safe distance, sure that you're not accidentally trampling its roots.

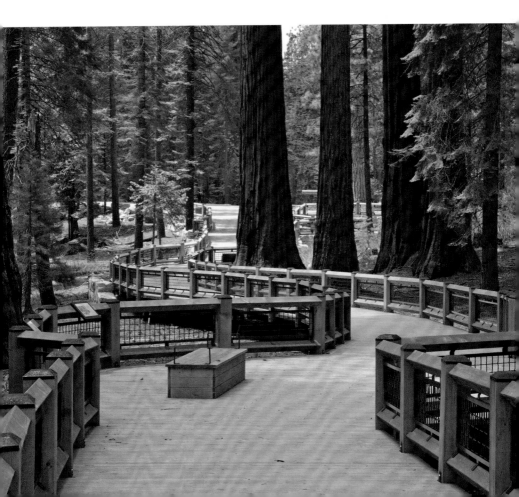

SEQUOIA SCIENCE FOR
AN UNCERTAIN FUTURE

I t's easy to see Mariposa Grove, and especially the Grizzly Giant, as emblems of resilience. Sequoias have stood through floods, droughts, earthquakes, and blizzards. They've persisted as human civilizations have risen and fallen around the world. Under optimal conditions, the Grizzly could live another thousand years or more.

To understand how the giants grow so big and for so long, scientists have measured mature sequoias, counted seedlings, and studied how soil and sunlight affect the trees. They've learned from local tribes about how to care for the trees, too, incorporating elements of traditional knowledge. In 1971, the NPS worked with tribal groups to reintroduce a traditional stewardship practice in Mariposa Grove: prescribed burns. Carefully managed, low-intensity fires can encourage sequoia growth by clearing the forest floor, opening the canopy to let light in, and drying cones to release seeds. These days, the NPS uses periodic prescribed burns as a forest-management technique in and beyond the grove. This type of forest management is credited with helping protect the Grizzly Giant and the grove during the Washburn Fire, which started just outside the grove and burned into it in 2022.

Today, a pressing scientific question looms: Can giant sequoias, including the Grizzly Giant, endure human-driven climate change?

One major threat is dwindling water supplies. The Sierra Nevada's once reliable winter snowpack is shrinking. Severe droughts and rising temperatures sap moisture from soil and trees. With dryer, warmer conditions, wildfires are burning more intensely and more frequently, blazing through parched vegetation. Sequoias have lived with fire for eons, but now they're struggling to withstand much hotter, higher blazes.

Another challenge is bark beetles, the wood-dwelling insects that thrive in warmer conditions and have killed millions of pines and firs across the Sierra. Scientists used to think sequoias were immune, thanks to their naturally pest-resistant bark, but that may be changing, especially as drought and fire weaken the trees' defenses.

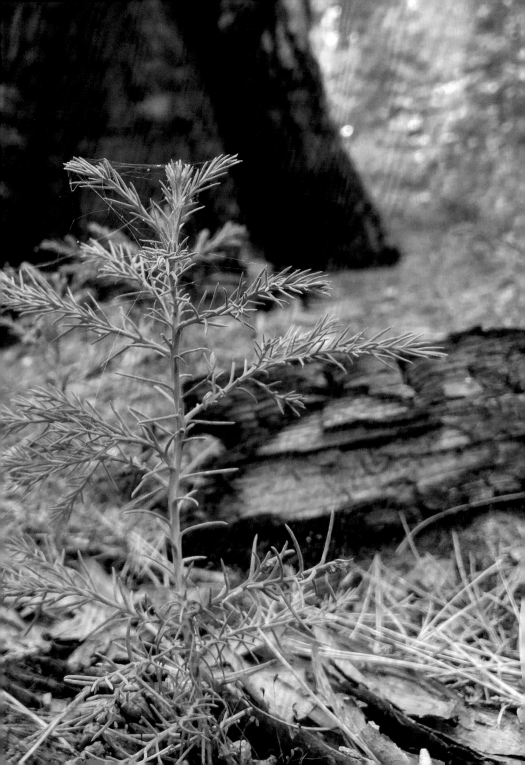

The renowned resilience of the species is flagging, and in some cases failing. Massive fires are killing sequoias across the Sierra— even the oldest and largest giants. Nearly twenty percent of the world's mature sequoias died or are dying from high-intensity fires in 2020 and 2021. That's 8,800 to 13,000 giant sequoias. The Mariposa Grove has about 500 large sequoias.

As park managers work to limit tree fatalities, such as by using prescribed burns to reduce potential fuel, researchers are racing to learn more about how climate change is transforming sequoias and their habitat. These recent fires are not the beneficial kind sequoias need, and the trees may not survive as a species. To better understand and protect the giants, scientists are studying the trees' water supplies, examining how habitat conditions play a part in sequoias' vulnerability, exploring beetle biology, and collecting cones for later replanting efforts.

The future of iconic trees like the Grizzly is up to all of us. Acting quickly means hope for the species—and for the giants' offspring, today's seedlings that could still be alive a thousand years from now.

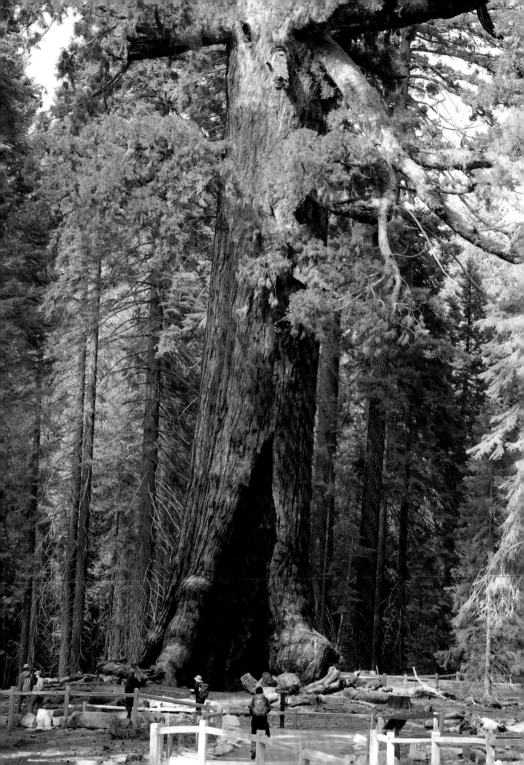

Visiting the Grizzly Giant

You can read about the Grizzly Giant, look at photos, and even virtually wander toward its wide trunk thanks to online resources. But the best way to understand this living icon is to visit it in person, at the southeastern edge of Mariposa Grove.

FINDING THE GRIZZLY

Your first step is to get to the grove (without pets, please). Park at the Mariposa Grove Welcome Plaza, just inside the park's South Entrance (off Wawona Road/Highway 41). When Mariposa Grove Road is open (typically April through November), a free shuttle will ferry you to and from the Mariposa Grove Arrival Area, a small plaza at the grove's entrance (elevation 5,600 ft/1,707 m).

If you'd rather stroll, hike the 2-mile (3.2 km) Washburn Trail from the Welcome Plaza to the Arrival Area. The trail partly follows an old stage road and gains about 500 feet (152 m) of elevation. Along the winding route, look for remnants of nineteenth-century stone walls, open views of forested hills, and western azaleas growing along streambanks.

From the Arrival Area, you can set off on hikes of varying lengths and difficulty levels. For now, let's take the Grizzly Giant Loop Trail. Start on the wooden boardwalk beside the Fallen Monarch sequoia, which toppled centuries ago. Follow the grooved trunk from crown to base; at the end of the boardwalk, get a close look at the tree's gnarled roots.

The loop continues up a gently sloped dirt path. You'll pass several still-standing sequoias and a tranquil wetland. Pay your regards to a quartet of named giants: the tightknit Three Graces, their trunks nearly touching, and the Bachelor, standing slightly apart from the trio.

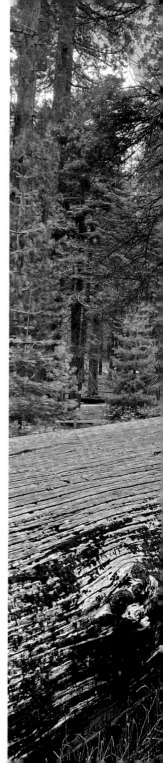

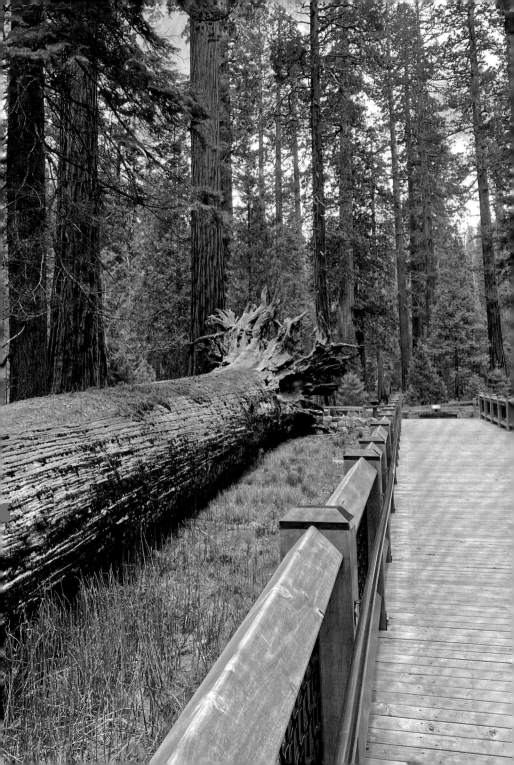

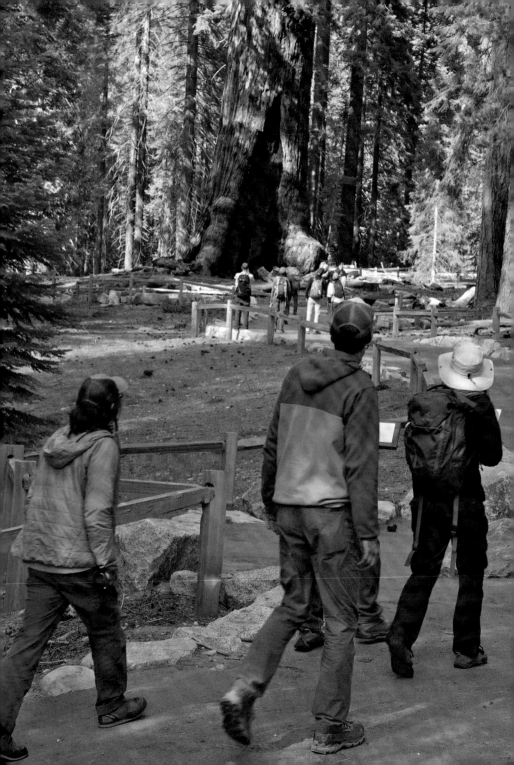

At this point, the Grizzly is around the corner! Okay, a few corners. But soon, you'll round a sharp curve and see it, off by itself. You'll know it by its massive, tilted trunk; limbs hooked at right angles; and the ghosts of old flames forming a charred scar.

When Mariposa Grove Road is open, vehicles with disability placards can drive to a designated parking area southwest of the Grizzly Giant. (Bicycles are also allowed on this route, but not anywhere else in the grove.) From there, follow the 0.13-mile (0.21 km) accessible trail to the iconic tree.

GETTING TO KNOW
THE GRIZZLY GIANT

From the Arrival Area to the Grizzly, you'll cover about 0.7 miles (1.1 km) and gain 300 feet (90 m) of elevation. Once there, take your time.

A fence keeps people a safe distance from the trunk, but you don't have to touch the tree to sense its scale. Settle onto a wooden bench in the clearing around the Grizzly's base; the benches are tilted back, so you can comfortably lean and gaze up. Look for holes caused by the self-pruning of branches and yellow-green lichen on the furrowed bark. Use binoculars or a camera to search for birds on high branches. Try to capture the Grizzly's colossal form in a panoramic photo—or use pencil and paper to sketch the tree without the limit of a lens.

Next, look around. Can you spot sequoia cones on the ground? If so, leave them in place, but imagine the hundreds of possible Grizzly descendants packed inside each small, scaly capsule.

Scan the surroundings for tiny green shoots and knee-high sequoia seedlings. You may spy an adolescent giant, growth spurt in full force, with the classic cone shape young sequoias develop as they sprint to sunlight. In sequoia terms, a "young" tree could be over a century old and as tall as a ten-story building.

Grizzly refers to the tree's gnarled look, not to any relation to the bear. Yosemite guardian Galen Clark is credited with having suggested the name *Grizzled Giant* in the late 1850s. (He also referred to the tree as "the Patriarch of the Mariposa Grove.")

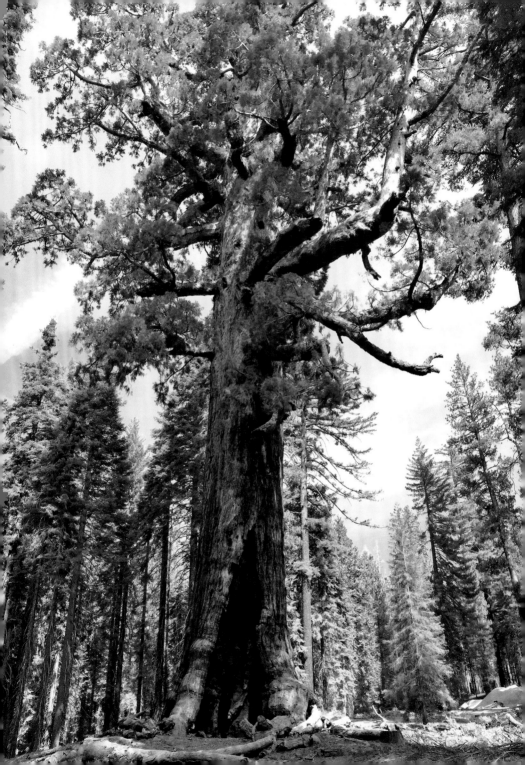

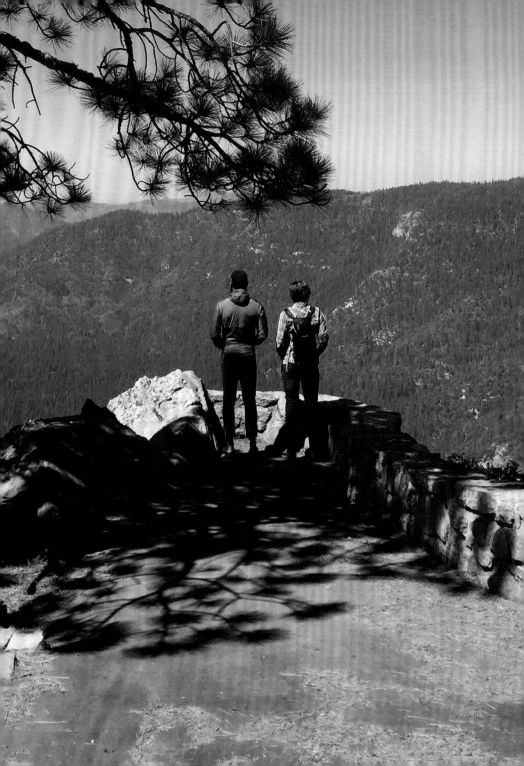

When you turn back to the Grizzly, notice the traits of a truly grown-up sequoia: at least 200 feet (60 m) tall; grooved, fire-scarred bark; and branches limited to the upper half of the broad trunk. And, of course, the snag top. Less battered, younger adult sequoias have rounded, broccoli-like tops; the Grizzly and its mature relatives earned their disheveled crowns by surviving centuries of harsh conditions.

MORE TO SEE

When you're ready to say goodbye to the Grizzly, there's plenty more to experience nearby. A few paces north, you can head to—and through—the California Tunnel Tree, carved out for tourists in 1895 and still standing. Follow the Mariposa Grove Trail uphill to meet the Faithful Couple (two trees melded at the base) and the naturally hollow Clothespin Tree, plus dozens of unnamed, equally impressive sequoias.

Continue up to Wawona Point (6,800 ft/2,073 m), an open spot overlooking southwestern Yosemite. On the way down, veer east onto the Guardians Loop Trail to see Galen Clark's namesake sequoia and a replica of his 1860s cabin.

Depending on your route from the Arrival Area, you could cover anywhere from 2 miles (3.2 km, Grizzly Loop) to 7 miles (11.3 km, to Wawona Point and back). Whatever loops you choose, help take care of the trees and other natural features as you travel through the grove. Leave cones and flowers where you find them, and carry out your trash. While it's tempting to give a sequoia a squeeze, stick to air hugs. Stay on trails and boardwalks to protect roots below the surface and seedlings starting their journey toward the sky.

Heads up: There are no visitor services within Mariposa Grove. Check the NPS website for information on facilities and conditions, and be aware that severe storms or other natural events sometimes prompt temporary closures and detours.

And, of course, Mariposa Grove isn't the only place to see giant sequoias. You'll find dozens of mature sequoias in Yosemite's Tuolumne and Merced Groves, both open all year. Beyond Yosemite, head south to Sequoia and Kings Canyon National Parks and Giant Sequoia National Monument, or north to Calaveras Big Trees State Park.

SEQUOIA SEASONS

You can visit the Grizzly Giant year-round, but access options vary, and some times are more crowded than others. The Grizzly's home in southwestern Yosemite is a popular destination especially when Mariposa Grove Road is open (typically April through November).

During those busy months, plan on an early start to get a parking spot at the Mariposa Grove Welcome Plaza. If you're in a car with disability placards, drive to the Arrival Area or the Grizzly Giant parking area. In winter, when the road is closed, walk, ski, or snowshoe up the road or the Washburn Trail.

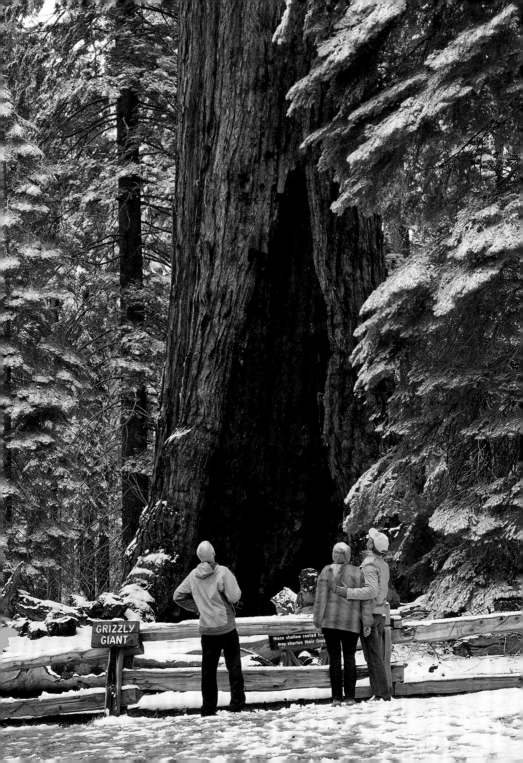

GRIZZLY
GIANT

these shallow rooted tr...
may shorten their lives

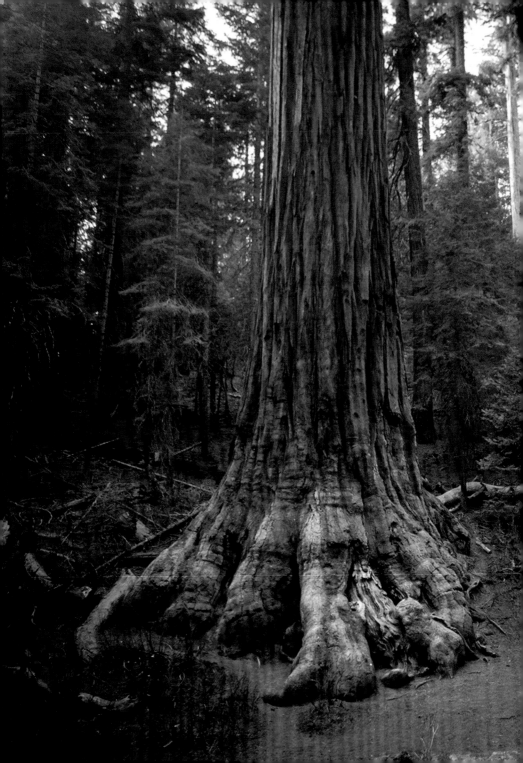

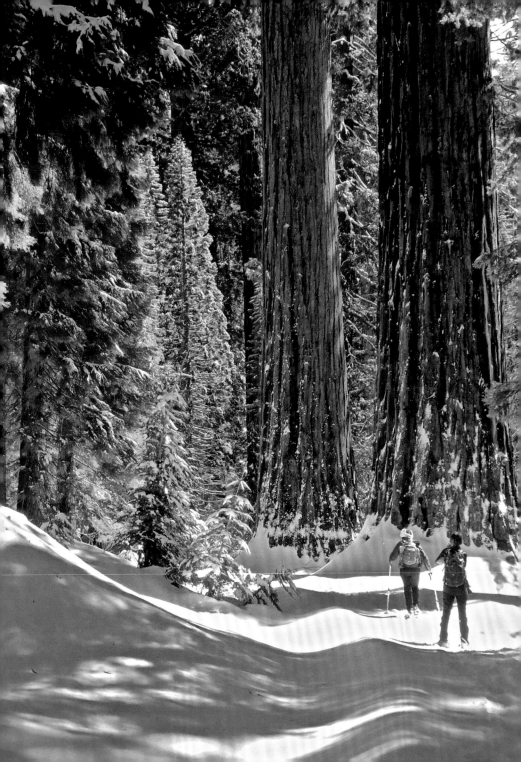

Sequoias don't change much from season to season, but the rest of the grove undergoes notable transformations. In spring, you'll see scarlet snow plants and purple broadleaf lupine. In summer, enjoy the cool shade as you look for mule deer napping in the Grizzly's shadow. In autumn, dogwood and black oaks brighten the deep-green forest with red and gold foliage.

Winter brings the most dramatic shifts. Deciduous trees shed leaves, making sequoias and other evergreens even more visible. Many animals are quiet, but Douglas squirrels keep moving, snacking on stashes of sequoia cones, and coyotes and owls hunt for small mammals. During this peaceful season, you can ski or snowshoe among the sequoias— and even camp (with a permit) in the upper part of the grove. Snow can pile up on branches and bury trails, so bring warm layers and winter navigation skills.

No matter the month, the Grizzly and its peers are living emblems of Yosemite's natural splendor— and reminders of the park's role in protecting land and life. Giant sequoias have a unique capacity to make us feel small, humble, and inspired, all at once. And they're still growing. Year after year, the Grizzly adds rings of wood, recording history in its trunk. Imagine the stories it could tell.

Yosemite's icons are far more than immense, stunning natural features. They also tell us about the park's past and present, and they prompt questions about its future. How can you help protect this iconic place for future generations?

RESOURCES

Check out these resources for more in-depth information on Yosemite, Mariposa Grove, and the Grizzly Giant, including natural and human history, things to see and do, places to stay, and ways to help protect the park.

Yosemite National Park: The National Park Service manages Yosemite National Park and is your best resource for the most comprehensive and up-to-date information about visiting the park, current conditions, natural resources, history, safety, and more.

WEBSITE: nps.gov/yose. For **trip-planning tips,** go to nps.gov/yose/planyourvisit. **CALL:** 209.372.0200 (general questions). For questions related to trip-planning and permits for the Yosemite Wilderness, including winter camping permits for Mariposa Grove, call 209.372.0826 (in service March through September).

Yosemite Conservancy: As Yosemite National Park's cooperating association and philanthropic partner, the Conservancy funds important work in the park and offers a variety of visitor resources and activities, including art classes, guided Outdoor Adventures and Custom Adventures, volunteer programs, and bookstores.

WEBSITE: yosemite.org. To see the Conservancy's four **Yosemite webcams**, visit yosemite.org/webcams. **CALL:** 415.434.1782

Yosemite Hospitality: A subsidiary of Aramark, Yosemite Hospitality, LLC, is an official concessioner of Yosemite National Park, and it operates hotels, restaurants, stores, visitor programs, and more.

WEBSITE: travelyosemite.com **CALL:** 888.413.8869 (U.S.) or 602.278.8888 (International)

The Ansel Adams Gallery: Located in Yosemite Village, the gallery celebrates Ansel Adams's work and legacy, showcases other photographers who capture the American West, and offers photography workshops.

WEBSITE: anseladams.com **CALL:** 209.372.4413

Voices of the People: This book by the Traditionally Associated Tribes of Yosemite National Park (Bishop Paiute Tribe, Bridgeport Indian Colony, Mono Lake Kootzaduka'a Tribe, North Fork Rancheria of Mono Indians of California, Picayune Rancheria of the Chukchansi Indians, Southern Sierra Miwuk Nation, Tuolumne Band of Me-Wuk Indians) offers detailed information and insights from the people native to the Yosemite area. Published by the National Park Service in 2019, ***Voices of the People*** is available from Yosemite Conservancy and digitally from most e-book vendors.

Ancient Forest Society: A nonprofit organization that studies ancient trees and forests in order to protect them.

WEBSITE: ancientforestsociety.org

Yosemite Nature Notes: This series of short documentaries about Yosemite dives into the park's geology, ecology, human stories, and more. For Grizzly Giant–related content, see Episode 34 ("Giant Sequoias"). Find all *Yosemite Nature Notes* episodes on the Yosemite National Park website (nps.gov/yose/learn/photosmultimedia/ynn.htm).

SELECTED BIBLIOGRAPHY

(pages 21, 22, 24, 25, 32, 33)

Sillett, Stephen C. Age, Biomass, and Growth History of Sequoiadendron giganteum in Mariposa Grove: Final Report to Yosemite National Park (study YOSE-00710, unpublished). March 22, 2017.

Sillett, Stephen C., Robert Van Pelt, Allyson L. Carroll, Jim Campbell-Spickler, and Marie E. Antoine. "Structure and Dynamics of Forests Dominated by Sequoiadendron giganteum." *Forest Ecology and Management* 448 (2019): 218–239.

PHOTO CREDITS

1: The Grizzly Giant. Photo by Yosemite Conservancy/Gretchen Roecker.
2, 3: Afternoon rainstorm in Yosemite. Photo by Phillip Nicholas.
4, 5: Canopy view, Mariposa Grove. Photo by Anthony Ambrose, Ancient Forest Society.
6, 7: Walking among giants. Photo by Josh Helling.
8, 9: Starry skies above the Grizzly Giant. Photo by Ron Bissinger.
10: Early morning in Mariposa Grove. Photo by Jane Rix/Shutterstock.
12, 13: Snowfall in Mariposa Grove. Photo by Ryan Alonzo.
14, 15: Green and drying sequoia cones. Photo by Anthony Ambrose, Ancient Forest Society.
16, 17: Giant sequoia bark. Photo by Phillip Nicholas.
19: Looking down the trunk of the Fallen Monarch, Mariposa Grove, Cal., USA. Troop D, 9th Cavalry, 1905. Courtesy of the Yosemite National Park Archives, Museum and Library, RL_19829.
20: Grizzly Giant branches in focus. Photo by Yosemite Conservancy/Gretchen Roecker.
22, 23: Grizzly Giant fire scar. Photo by Yosemite Conservancy/Gretchen Roecker.
24: The Grizzly Giant, Mariposa Grove, Yosemite, 1861. Photo by Carleton E. Watkins. Gilman Collection, Purchase, Gift of The Howard Gilman Foundation, by exchange, 2005. Accession number 2005.100.618.
25: The Grizzly Giant, 2016. Photo and framing for comparison with p. 24 by Robert Van Pelt.
26, 27: Evening light in Mariposa Grove. Photo by Mike Reeves Photography.
28: Douglas squirrel (chickaree) in Yosemite. Photo by Raj Joshi.
29: Great gray owl and Steller's jay in Mariposa Grove. Photo by Nigel Voaden.
30: Sequoia companion plants. Photo by Anthony Ambrose, Ancient Forest Society.
31: Snow plants. Photo by Josh Helling.
33: The epiphytic ponderosa pine in the Washington Tree. Photo by Stephen C. Sillett.
35: Prescribed burn in Mariposa Grove, 2017. Photo by Yosemite Conservancy/Romina Pasten.
36: Superintendent W. B. Lewis and visitors encircle the Grizzly Giant, 1922. Courtesy of the Yosemite National Park Archives, Museum and Library, RL_17705.

38, 39: Canopy view, Mariposa Grove. Photo by Anthony Ambrose, Ancient Forest Society.
40, 41: Theodore Roosevelt, John Muir, and others at the base of the Grizzly Giant, 1903. Courtesy of the Yosemite National Park Archives, Museum and Library, RL_13724.
42, 43: An updated look for Mariposa Grove. Photo by Josh Helling.
44: Interpretive signs, Mariposa Grove. Photo courtesy of NPS/Al Golub.
45: A boardwalk protecting sensitive wetland plants. Photo by Josh Helling.
46: Smoky sunset view from Mariposa Grove Road. Photo by Isaak Berliner.
48, 49: Generations. Photo courtesy of NPS.
50: KNP Complex Fire in Redwood Mountain Grove, within Kings Canyon National Park and Giant Sequoia National Monument, October 4, 2021. Photo courtesy of NPS/Joe Suarez.
52: Visiting the Grizzly Giant. Photo by Josh Helling.
54, 55: The Grizzly Giant Loop trail begins. Photo by Carolyn Trimble Botell.
56, 57: Approaching the Grizzly Giant. Photo by Josh Helling.
59: Sequoia seedling. Photo by Yosemite Conservancy/Heather van der Grinten.
61: The Grizzly Giant. Photo by Yosemite Conservancy/Jennifer Miller.
62: Wawona Point view. Photo by Yosemite Conservancy/Jennifer Miller.
65: The Grizzly Giant after a light snowfall. Photo by Nancy Robbins.
66, 67: Fascinating giants. Photo by Ryan Alonzo.
68: Snowshoe outing. Photo by Debra Sutherland.
Back cover: Base of the Grizzly Giant. Photo by Kenneth Sponsler/Shutterstock.

YOSEMITE CONSERVANCY.

yosemite.org

Yosemite Conservancy inspires people to support projects and programs that preserve Yosemite and enrich the visitor experience for all.

Text by Gretchen Roecker
Book design by Eric Ball Design
Cover art by Shawn Ball

ISBN 978-1-951179-28-1

Printed in China by Reliance Printing

1 2 3 4 5 6 – 27 26 25 24 23

MIX
Paper from responsible sources
FSC® C102842